THE HEART OF HAITI

THE HEART OF HAITI

PHOTOGRAPHS BY

ANDREA BALDECK

UNIVERSITY OF PENNSYLVANIA MUSEUM OF ARCHAEOLOGY AND ANTHROPOLOGY
PHILADELPHIA

Cataloging in Publication Data available from
the U.S. Library of Congress, Washington, DC

ISBN 1-931707-85-5

The creole proverbs found in this book are adapted
from the book *Parol Granmoun: Haitian Popular Wisdom*
(Port-au-Prince, Haiti, 1976) by Edner A. Jeanty and
O. Carl Brown. We are very grateful to Pastor Jeanty for
allowing us to use his fine work.

Other Books by Andrea Baldeck:

Rudolf Staffel: Searching for Light, 1996

Hollis: Sonata Sonnets & Las Espinas, 1998

Breon O'Casey: In Honor of His Seventieth Birthday, 1998

Talismanic, 1998

Venice a personal View, 1999

Touching the Mekong, 2003

Hollis: Dark Encounter In Mid Air, 2004

Printed in the USA on acid-free paper

THIS BOOK IS DEDICATED

TO THE PEOPLE

OF THE ARTIBONITE VALLEY

HAITI

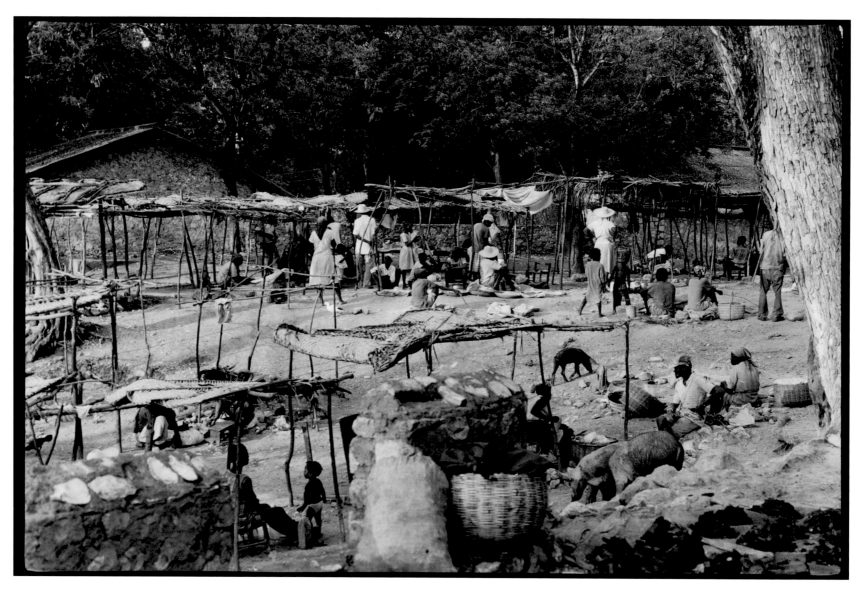

OU OUÈ JODI; OU PA KONN DÉMIN.
You see today; you don't know tomorrow.

Heat, confusion and cacophony fill the arrivals hall at the Port-au-Prince airport. Skirting duct-taped boxes, lumpy suitcases and clots of travelers, I head for the swirling bottleneck that is the douane. A small "cadeau" slipped into the right hands prevents total upending of my duffel, which I drag out to the concrete apron and into the remorseless glare of a tropical afternoon. Relief arrives with the sighting of a tall, straw-hatted Haitian bearing a placard that reads "HAS — Hôpital Albert Schweitzer," who loads the Jeep, navigates the automotive scrum of the parking lot, and guides us onto the coast road leading north out of the steaming capital.

It's September, the trailing edge of the rainy season, and I'm on my way to a destination imagined and planned for, but not yet seen, a hospital deep in the interior of Haiti, to volunteer my service as a young physician. As we follow the tarmac, the sea dazzles off to the west, reflecting towering, sculptural clouds that bode a late afternoon storm. Drifting inland, they cast their mobile shadows over the stark, furrowed slopes of denuded mountains, long shorn of their forest cover. Gazing at the landscape, imposing, baked and desolate, I reflect on the route that has led me to Haiti, scarcely believing the reality of my arrival. Growing up in rural America, and finding transport in childhood accounts of intrepid explorers and humanitarians like Albert Schweitzer, I dreamt of

adventures to far-flung corners where I could be not just voyager or voyeur, but a healer, armed with medical skills and a Gladstone bag. Years separated the dream from the reality, and circuitous routes led me onto side roads through music and teaching, before medical school and residency brought me to this point, en route to the hospital built and named for Schweitzer by his American friend and protégé, the remarkable Dr. Larry Mellon.

The sun's rays lengthen over the sea and throw into sharp relief one-room dwellings on slopes where gaunt livestock graze. Elongated shadows keep pace with barefoot travelers balancing loads on their heads and driving laden donkeys. In jumbled roadside towns our pace slows, through outdoor markets pulsing with commotion, color, and clouds of dust, a daily enactment of the improvised riff that is Haitian life. We turn inland toward Deschapelles, following the Artibonite River deep into the rice-growing plain at the country's center. Pavement surrenders to a dirt track that speaks graphically of the rainy season: a vocabulary of ruts, ridges and mud, punctuated by expansive puddles. The driver threads this maze with muscular concentration, assessing in his gaze the perils of the route and the traffic on it — trucks, brightly painted camions that serve as public transport, and countless pedestrians, making their way home in the waning afternoon. Slanting shafts of light pierce the trees

to touch cottages of mud and wattle, thatched in palm fronds. Clean-swept communal courtyards between them speak of life lived outdoors; pots simmer on open cookfires redolent of charcoal, chickens and feisty pigs scatter before pursuing children, and thin-haunched dogs curl up in the shade. The cool of deepening twilight invites movement freed of the day's heavy loads, time for visiting, socializing, storytelling. Lamps and candles bob and swarm like fireflies, blinking, vanishing, and re-emerging as their carriers weave among the trees.

Darkness is velvety and profound in rural Haiti, where few know electricity. The Jeep's headlights peer through heavy air, penetrating just far enough ahead to reveal the next rut, or a tethered goat at the roadside, startled by our commotion. Are we on the right track? Anxiety seeps into my thoughts, but a glance at my driver shows his unperturbed face. Nothing to do but sit tight and watch the patch of road ahead. At last, looming out of the brush at the edge of Deschapelles village, bright in our high beams, is a sign bearing a bold arrow and the words "Hôpital Albert Schweitzer." We've arrived.

Ayiti, the "high place" of its indigenous tribes, entered Western consciousness with Columbus's sighting of a land verdant and fruitful. Anchored offshore at the mouth of a river, he described what he saw as Paradise Valley, a place of seeming ease and plenty. In the intervening centuries, exploitative colonialism and its plantation system radically altered the face of the land. By the late 18th century, one-third of France's foreign trade came out of an island economy fueled by enslaved West Africans. Radicalized by the French Revolution, they rose in revolt to expel the old order, joining the United States as the second republic in the Western Hemisphere. Unease and aloofness characterized relations between this nation of liberated blacks and its slave-holding neighbor to the north. The newly free Haitians were left to their own devices, to craft a state in a setting irrevocably altered from the paradise envisioned by Columbus — deforested, depleted, disrupted — that remains today's reality. Volumes of commentary detail how this came to be, but the distilled wisdom of Haitian experience paints it in trenchant proverbs:

"Ayiti sé tè glisé." (Haiti is slippery ground.)
"Lavi sa-a sé boukanté mizè pou traka." (In this life one exchanges misery for more troubles.)

Phrases like these, born of hardship, hunger, and disease, are spoken by the patients in the river valley who come to the hospital — on foot, on horseback, and on rattletrap vehicles — seeking help. They bring with them equal measures of hope and uncertainty, along with illnesses that catalogue scourges both ancient and modern.

In the wasted frame and feverish gaze of a gaunt young man lives the "galloping consumption" of tuberculosis, a specter from 19th century novels. A father carries to the door a rigid child, her face frozen in a painful rictus, the "sardonic smile" that is the grip of tetanus. A twenty-five-year-old, ashen and weak, comes after a stay with the *vodoun* healer has failed to cure: beset by a bewildering series of infections, followed by lymphoma, he declines precipitously with advanced AIDS. In the waning rainy season, standing water breeds mosquitoes that spread malaria in all its protean forms, filling clinic corridors with the fevered, who, waiting to be seen, seek relief by lying on the cool concrete floors. Typhoid knows no season, thriving where clean water is scarce and sanitation lacking; malnutrition stalks the young, sending desperate mothers with bloated children in search of supplemental food and milk.

Serving at Hôpital Albert Schweitzer forever alters one's consciousness and conscience. Life in Haiti is intense, arduous, and too often brief. Stoic Haitian faces tell of the struggle to endure in a harsh world, where death is a close neighbor. Spiritual succor and transport are sought in worship of *vodoun loas*, the pantheon of West African ancestral deities. No church-bound saints, these supernatural forces, light and dark, animate nature and color daily life. My Western rational skepticism

dismissed this commingling of the seen and unseen until I watched my patients, emerging from anesthesia, invoking the gods.

Haiti, in her uniqueness and contradictions, beguiled me from my first sojourn there in 1981. Her culture and people drew me back to practice medicine twice more, in 1983 and 1985, where the satisfaction of making an acute difference was tempered by the frustrations of chronic poverty. Living in the geographical heart of the country, I learned more than I could teach, and came away with more than I could give. I grew to respect the strength, resilience and spirit of the Haitian people, who conduct their lives with dignity and season their talk with proverbs. These encounters created compelling memories, which I carried away as indelible images in my brain.

The years between my visits to the island brought roller-coaster political change, fueled by violence and hope. The dictatorial regime of the Duvaliers fell, and activist priest Jean-Bertrand Aristide won the presidency. A brutal military coup, exiling him for three years and suppressing his followers, ended with American intervention in 1994. With the restoration of Aristide to the presidency came a brief spell of euphoria; there was reason to believe the worst had passed, and that positive change could come to Haiti. Hôpital Albert Schweitzer had weathered the

storms of internal unrest, remaining open even when danger reached its doorstep. Working stateside with many others to support the hospital, I yearned to revisit it, and those who had led it through dark times, among them Madame Gwen Mellon, the founder's widow. By 1996, I had exchanged stethoscope for camera to pursue a new career, and returned to Haiti as a photographer.

Cameras in hand, I began at the hospital, central to my experience and to the life of the valley, visiting familiar haunts in clinics and wards, walking the campus that began its life as a banana plantation. From there, my circle widened. Hopping Jeep rides with outreach workers into the 200-square-mile district served by the hospital, I met farming families, craftspeople, and village health workers; teachers, engineers and a *vodoun* priest, who bartered his portrait for my hat and gently sent me off before night fell and the ceremonies began.

During this journey through rural Haiti, I encountered humanity in its leanest essence. The unveiled, straight-ahead gazes of those looking back unflinchingly at the camera bespeak a world of experience beyond ours, a place where rules for living are hard and immutable. These images — faces and stories that never reach the pages of American newspapers — became a book of portraits, privately printed in 1996 to provide publicity and fund-raising support for the hospital. The present offering includes more photographs and Creole proverbs.

The intervening years have brought neither peace nor progress to Haiti. Failed government, unrest in the countryside, environmental degradation and infrastructural collapse threaten the already precarious existence of her people. The press brings us sensational accounts of lawlessness and havoc spreading far from their epicenter in the slums of Port-au-Prince, fueled by decades of desperation and failed hopes. Warring thugs and opportunistic predators are not enough to long hold the attention of developed countries: depleted Haiti holds nothing the world desires. Lacking strategic oil reserves, not yet a hotbed of international terrorism, it is readily dismissed by world powers. Haiti, a near Caribbean neighbor, is literally off the map of our understanding, and a blind eye turned to its woes only diminishes us in our shared humanity. Words alone will never adequately describe the complex topography — physical or spiritual — of this island nation. Images reach where language cannot, touching the viewer in a deeper, older, more visceral place. It is my hope that these portraits will reveal the true heart of Haiti in a way that is both seen and felt.

Andrea Baldeck

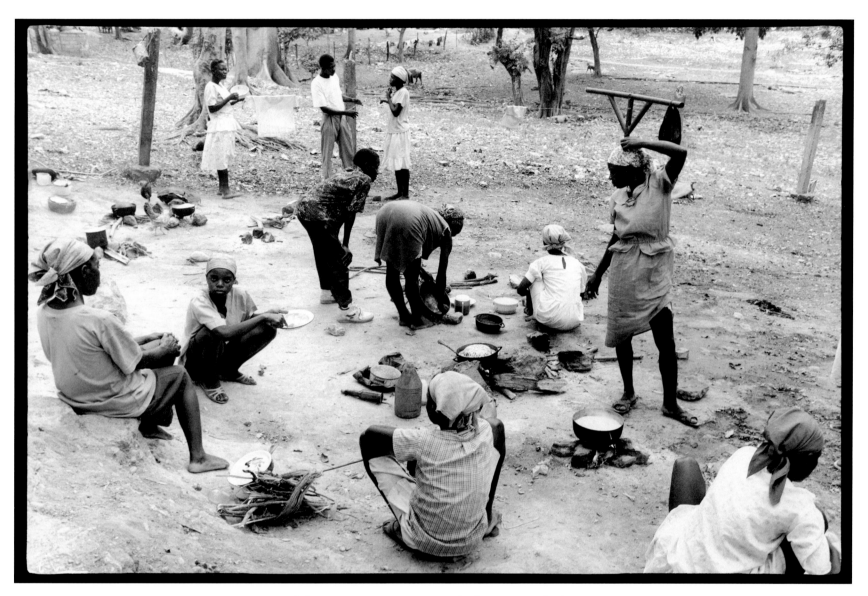

SÉ GOU BOUYON KI MÉTÉ LANG DÉYÒ.
It's the taste of broth that draws the tongue.

Contents

SÉ PITI M-PITI; M-PA PITIMI SAN GADÒ.

It's little, I'm little; I'm not a little grain with no guardian.

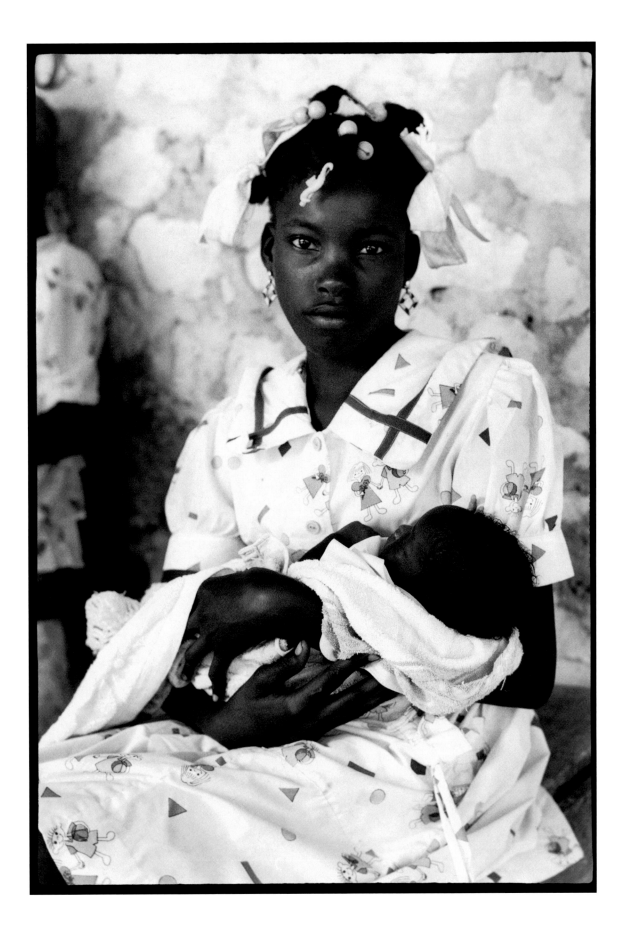

TI MOUN KI MANKÉ MOURI DIMANCH,
SÉ DIMANCH POU-L MOURI.

The child who almost dies Sunday on Sunday must die.

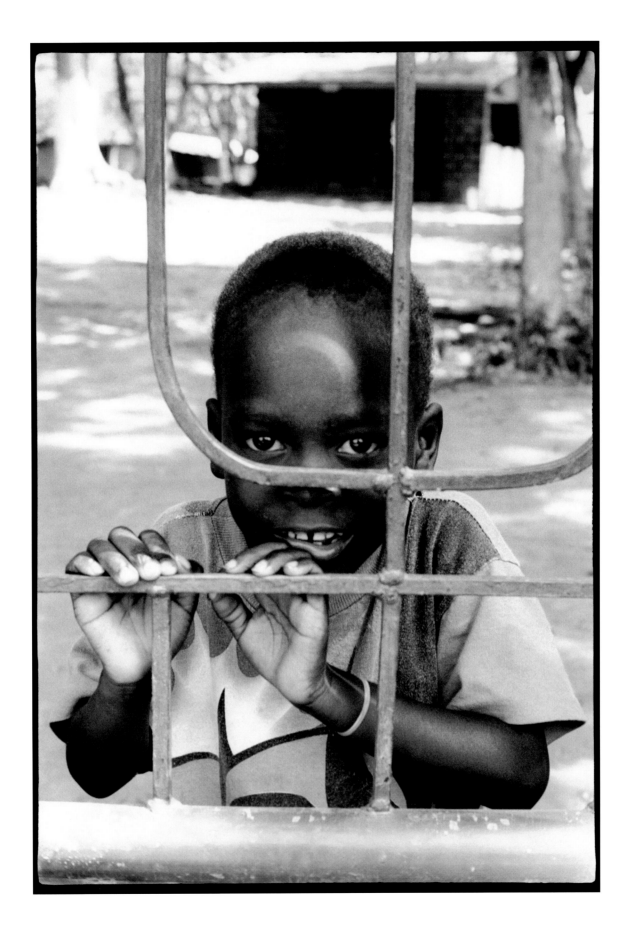

KRÉYON BON DIÉ PA GIN GONM.

God's pencil has no eraser.

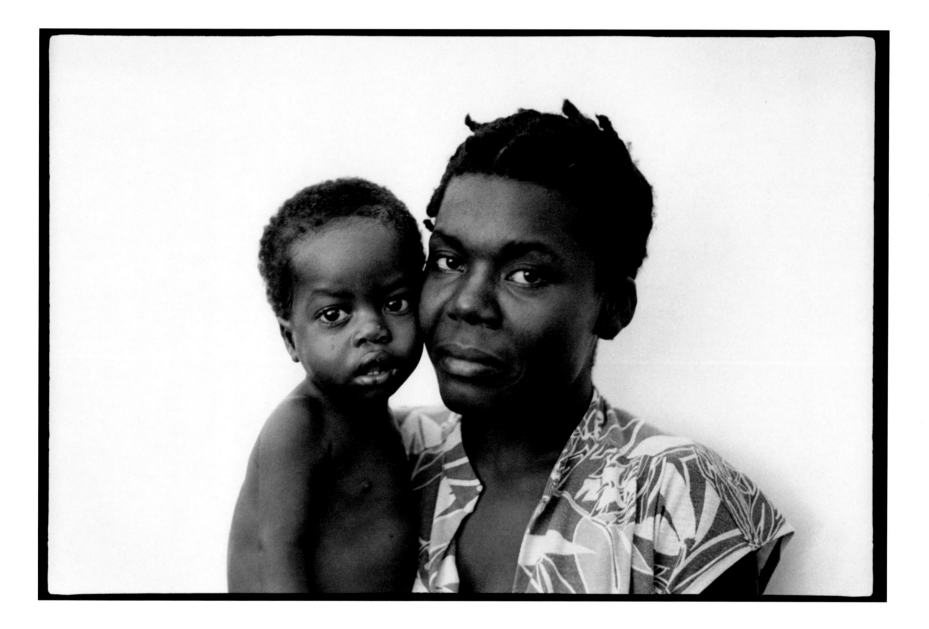

BYIN PRÉ PA RIVÉ.

Being near isn't arrival.

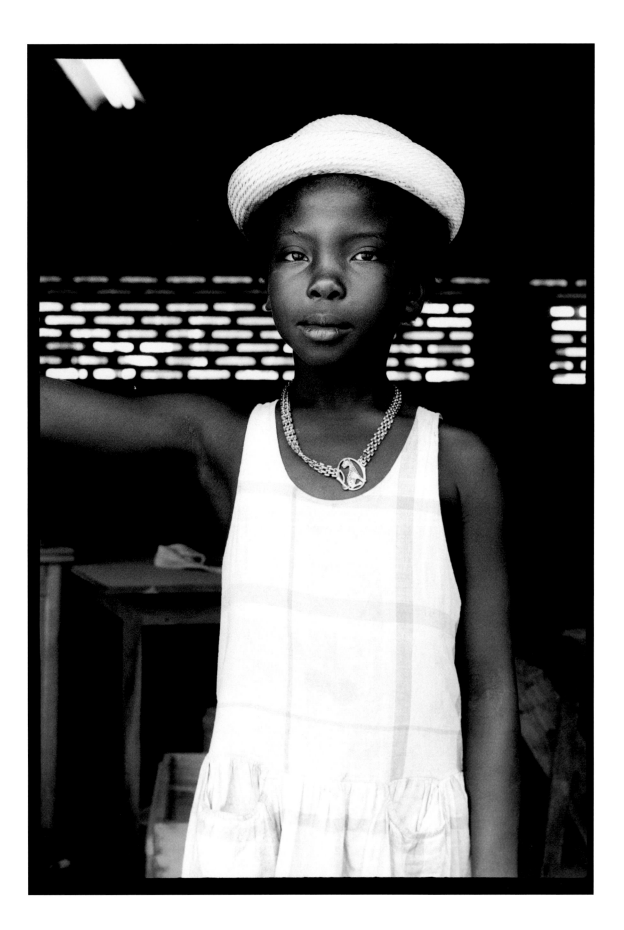

LAVI SÉ YOU PANTALON DÉFOUKÉ, SAN BRÉTÈL,
SA — SÉ LAVI AN AYITI.

Life in Haiti is pants with open crotch, without suspenders.

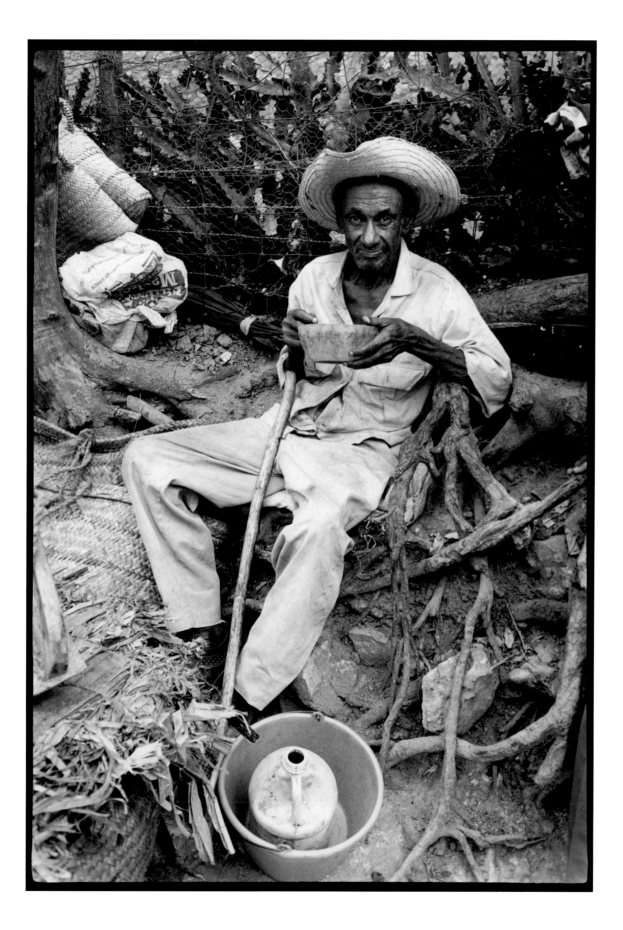

RÉT TRANKIL SÉ RÉMÈD KÒ OU.

To rest quietly is remedy for the body.

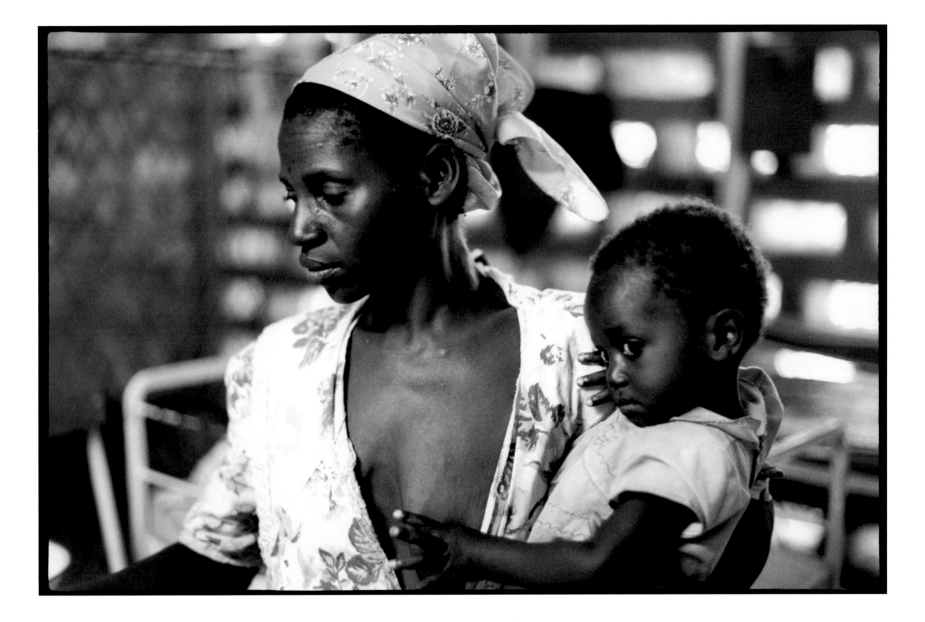

FÈ TAN, KITÉ TAN.

Make time or you'll quit time.

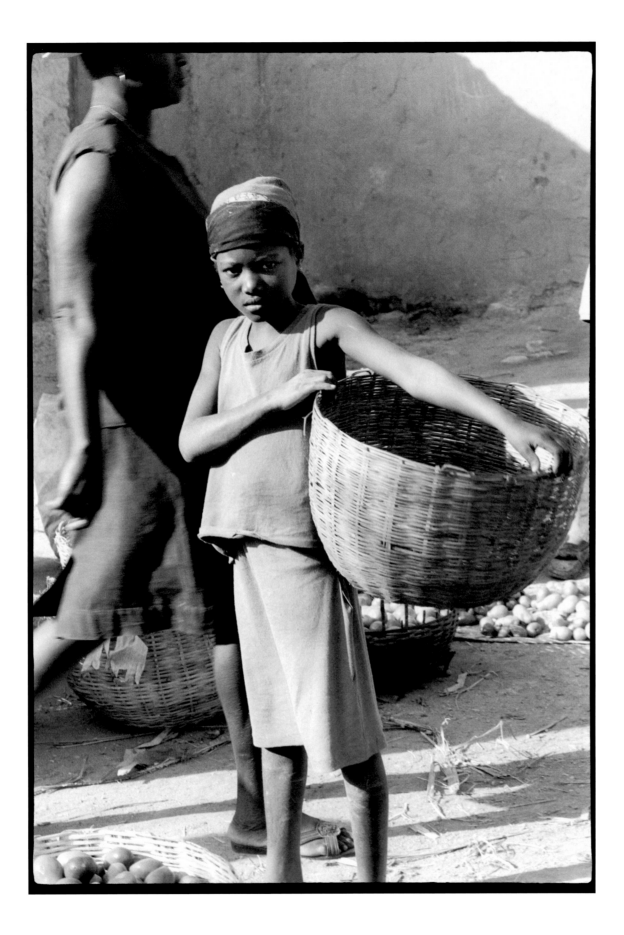

GRANGOU NAN VANT PA DOUS.

Hunger in stomach isn't sweet.

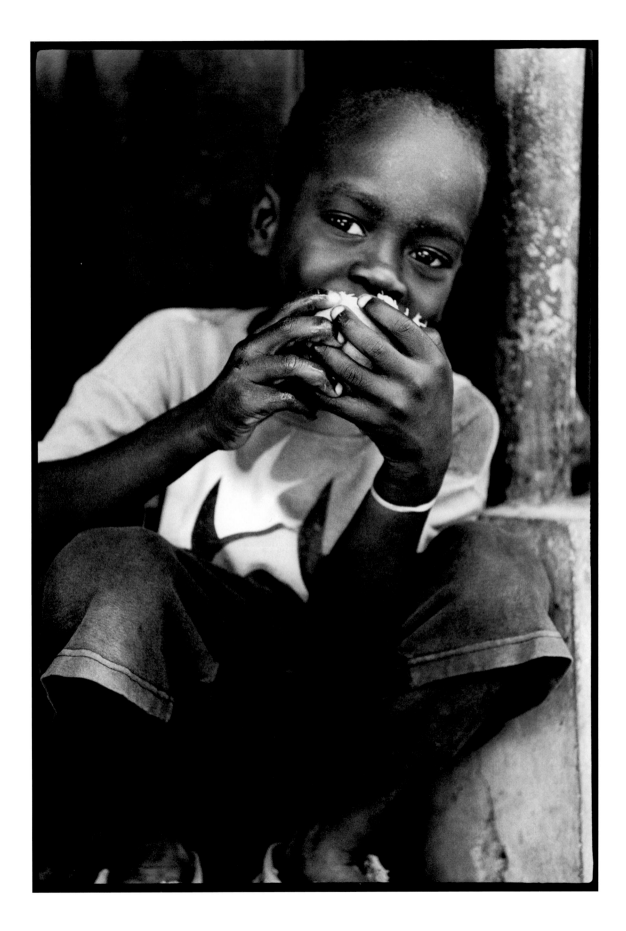

FIGU OU SÉ PASPÒ OU.

Your face is your passport.

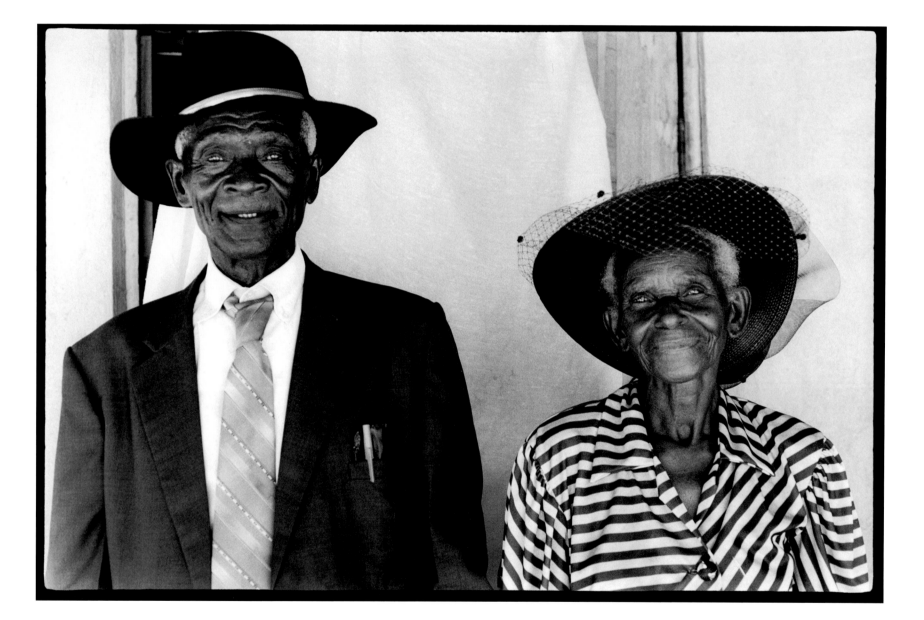

MIZÈ FÈ BOURIK KOURI PASÉ CHOUAL.

Misfortune makes a donkey run faster than a horse.

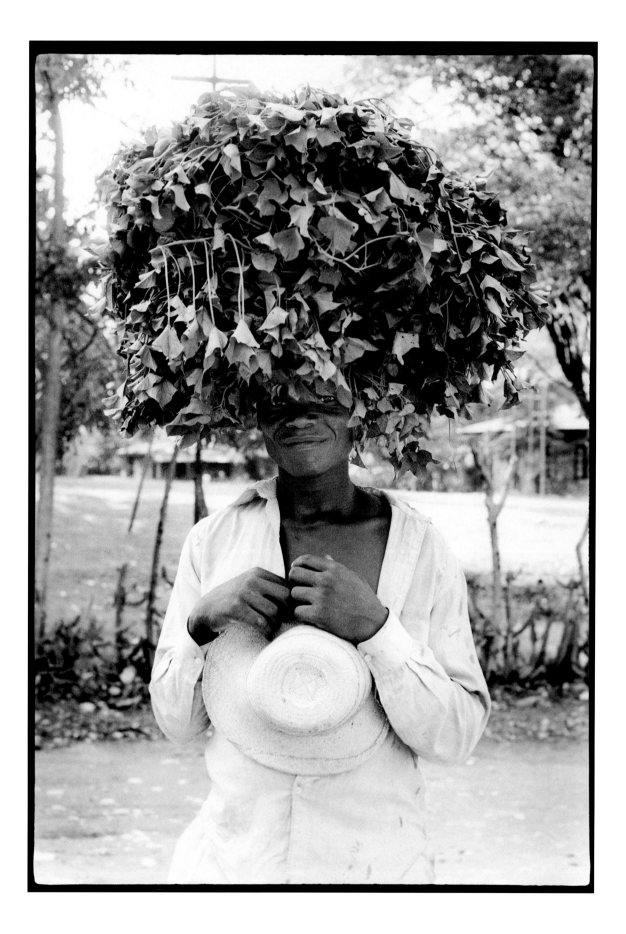

KITÉ PARÒL, PRAN KANTIK.

Leave words and take a song.

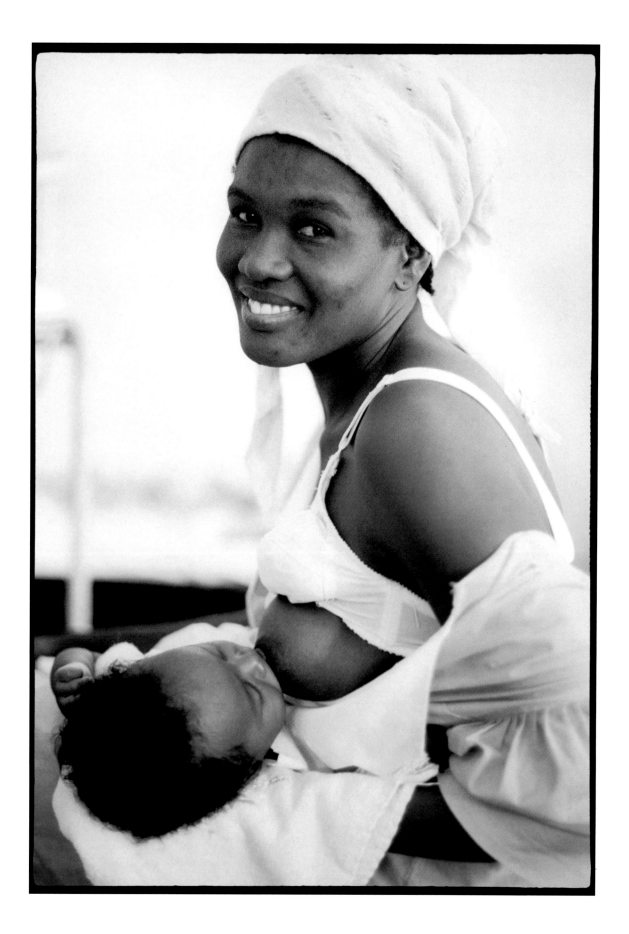

SI OU PA LION, FÈ OU RÉNA.

If you're not a lion be a fox.

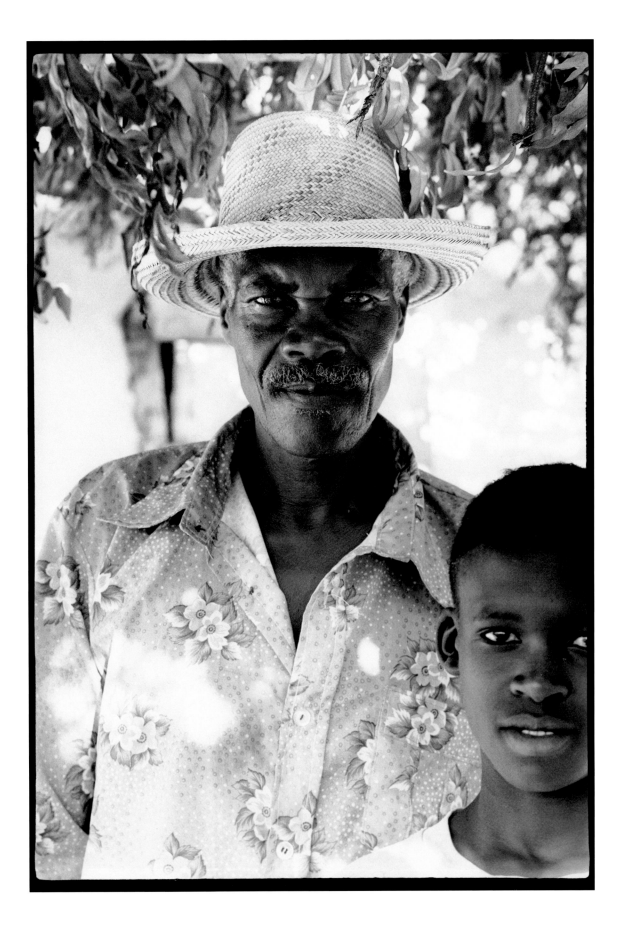

DÈYÈ MÒN GIN MÒN.

Beyond mountains are mountains.

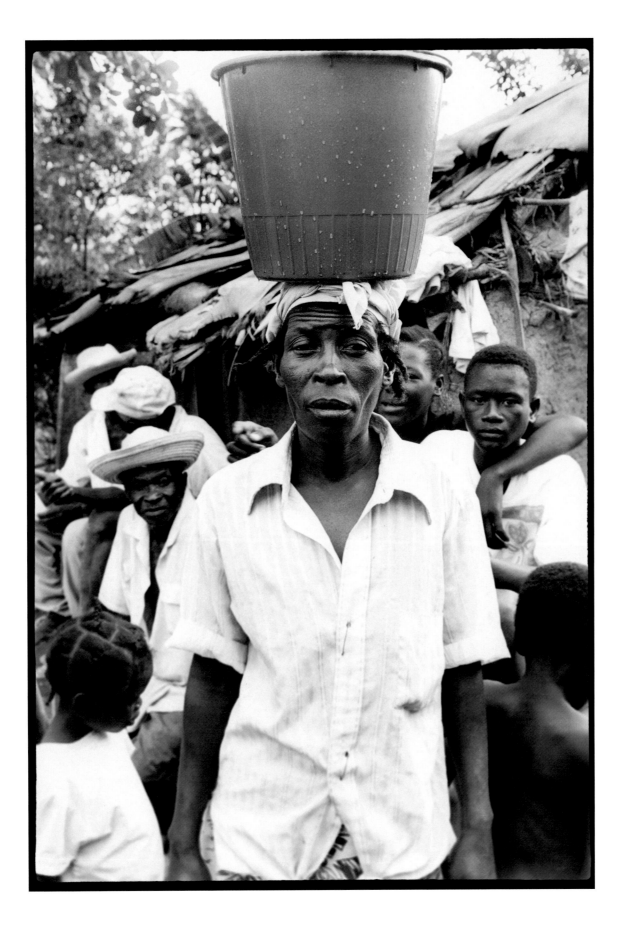

PARÒL NAN VANT PA POURI TRIP.

Words in the belly don't rot the guts.

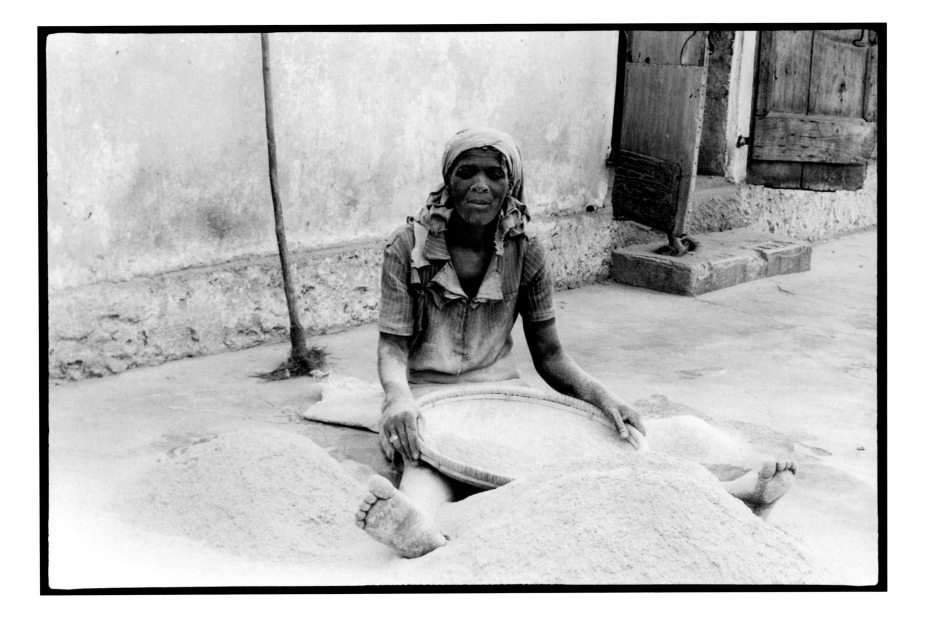

JÉ OUÈ BOUCH PÉ.

Eye sees, mouth silent.

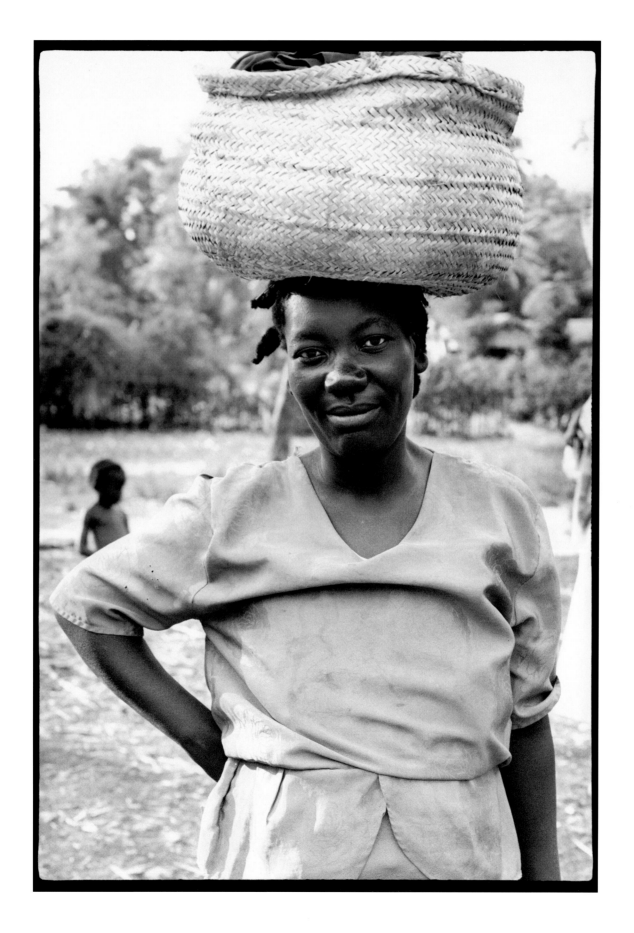

PITI PITI PLIN KAY.

Very little fills up the house.

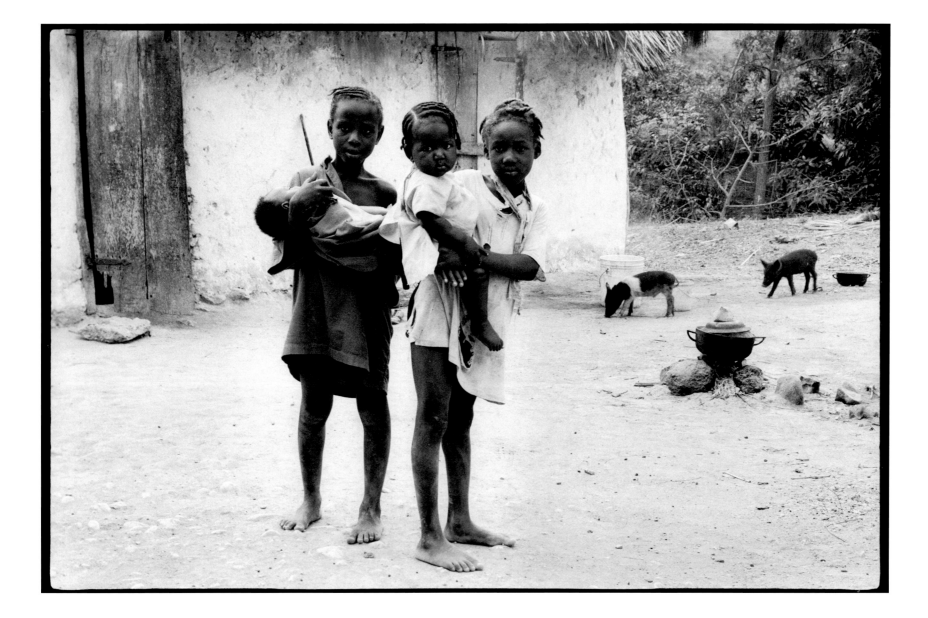

FANM SÉ KAJOU: PLUS LI VIÉ, PLUS LI BON.

Woman is mahogany tree: more she's old, more she's good.

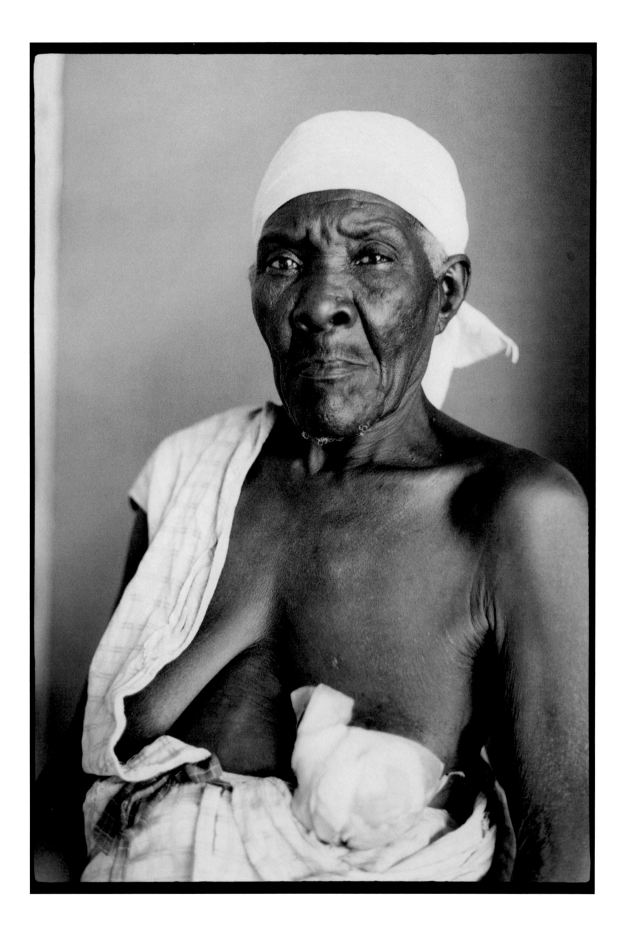

TIG VIÉ MIN ZONG LI PA VIÉ.

Tiger old but claws never old.

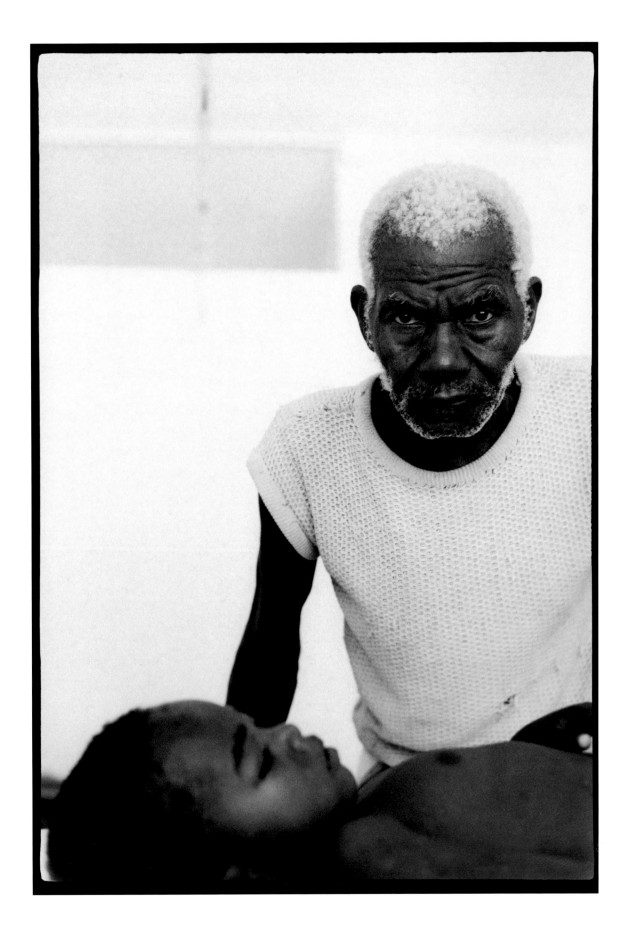

YO PA KA ACHTÉ MOSO MANMAN NAN MACHÉ.

They can't buy a piece of mother in the market.

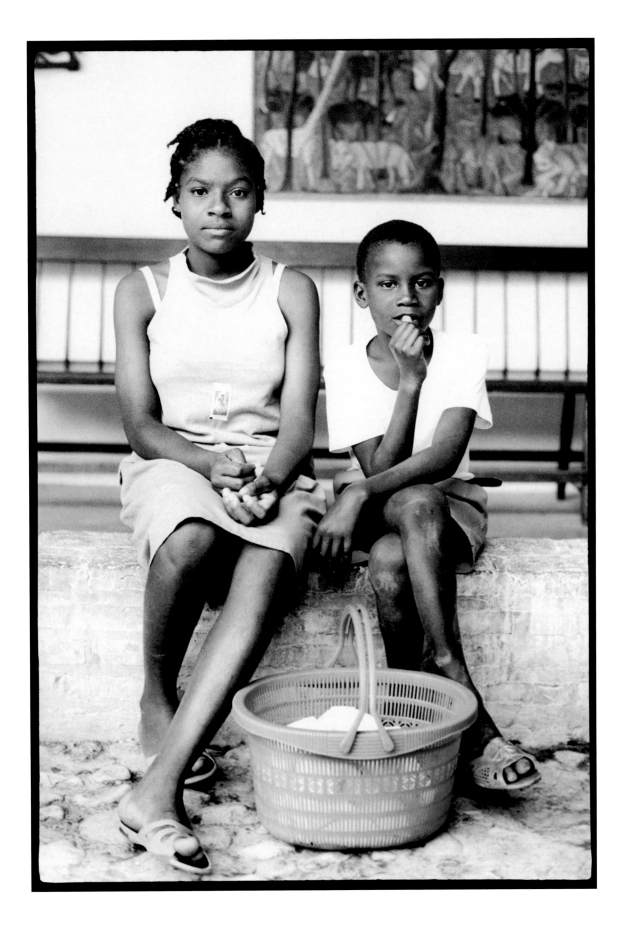

OU SÉ PAPIYON, MOUIN SÉ LANP.

You are butterfly; I am lamp.

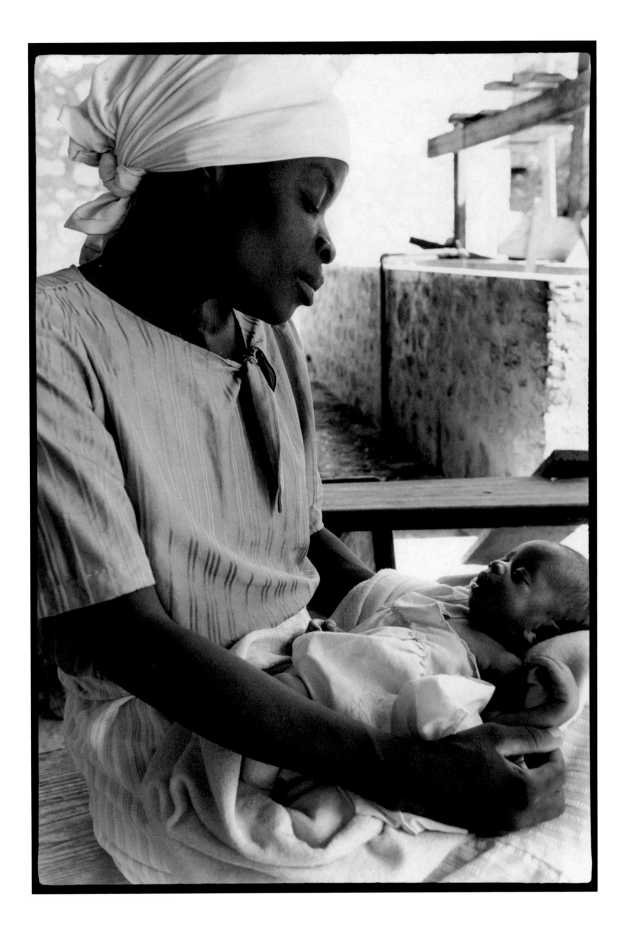

BYIN MAL PA LANMÒ.

Very sick is not dead.

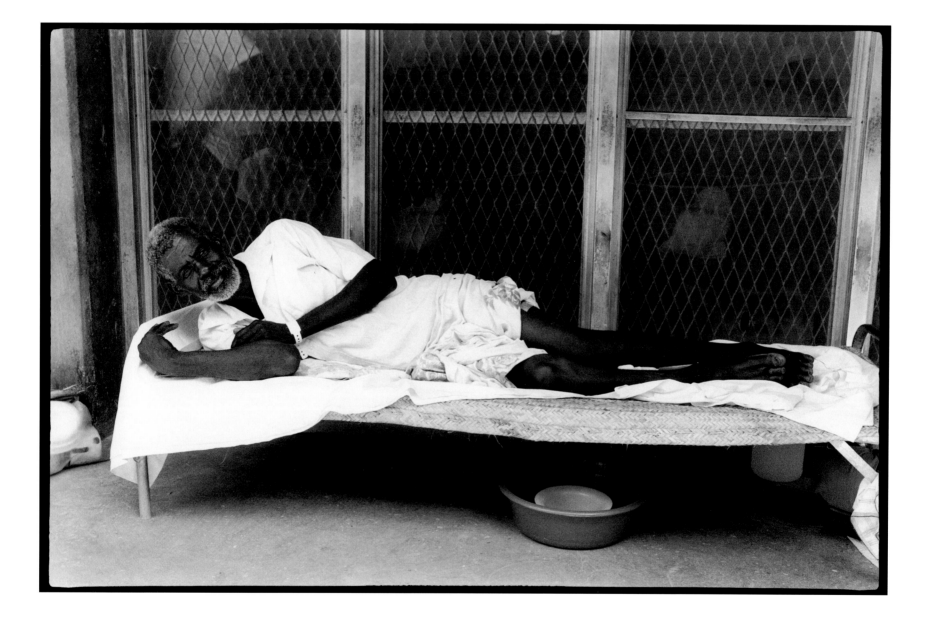

LÉSPOUA FÈ VIV.

Hope makes one live.

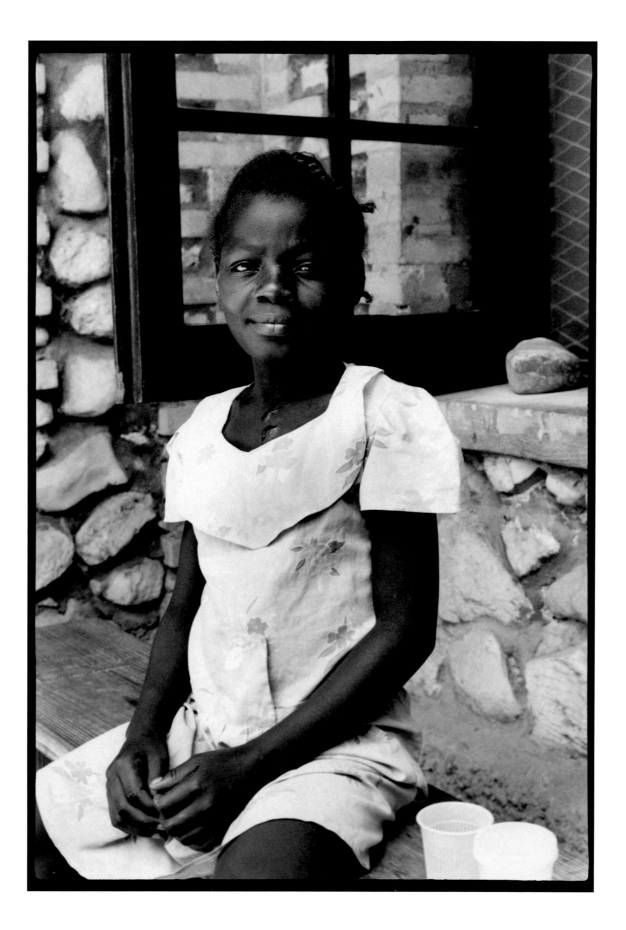

CHIN-K GRANGOU PA JOUÉ.

A hungry dog doesn't play.

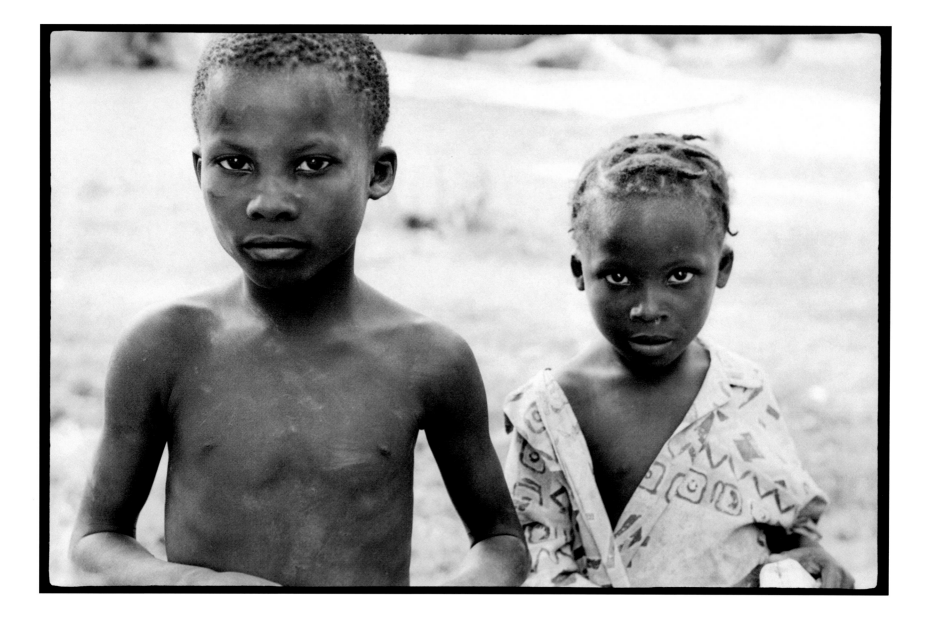

DAN RI DANJÉ.

Teeth laugh at danger.

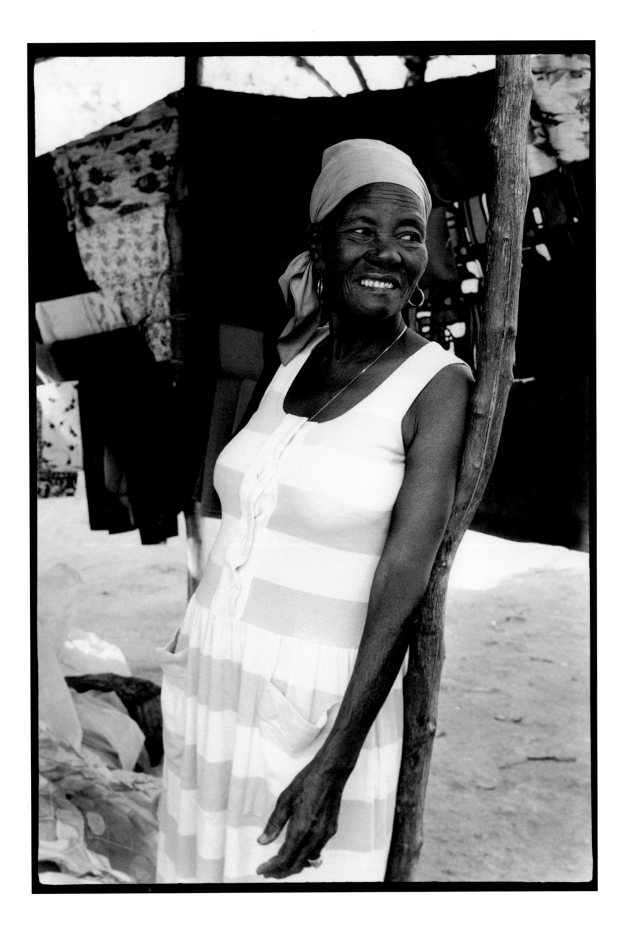

APRÉ LAMÈS SÉ VÈP.

After mass is vespers.

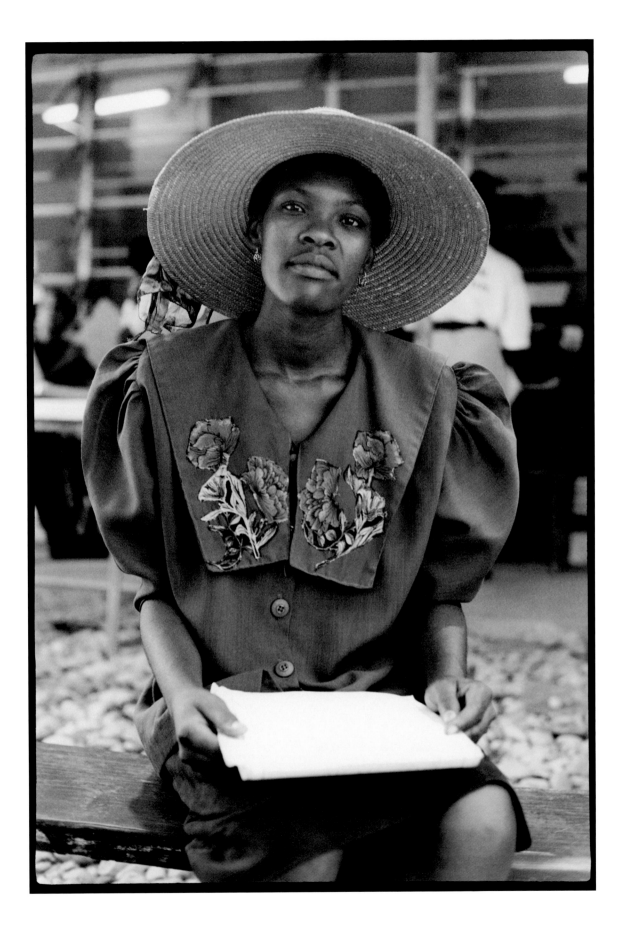

AK PO KÒ OU OU VINI, AK PO KÒ OU OU PRALÉ.

With your skin you came; with your skin you go.

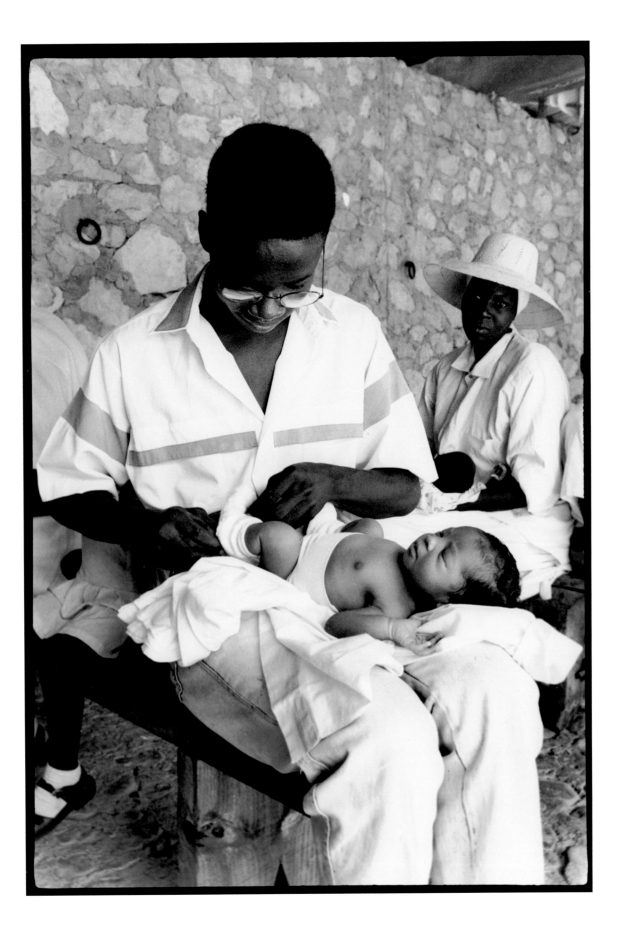

CHITA TENDÉ, MACHÉ OUÈ.

Sit and hear, walk and see.

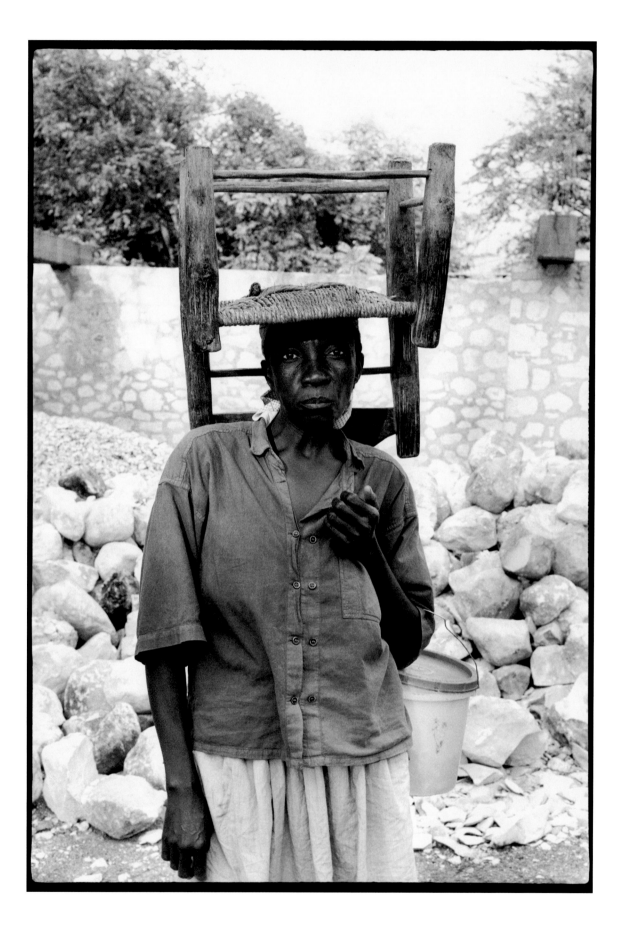

PISÉ TIG PA BIÈ.

Tiger's piss ain't beer.

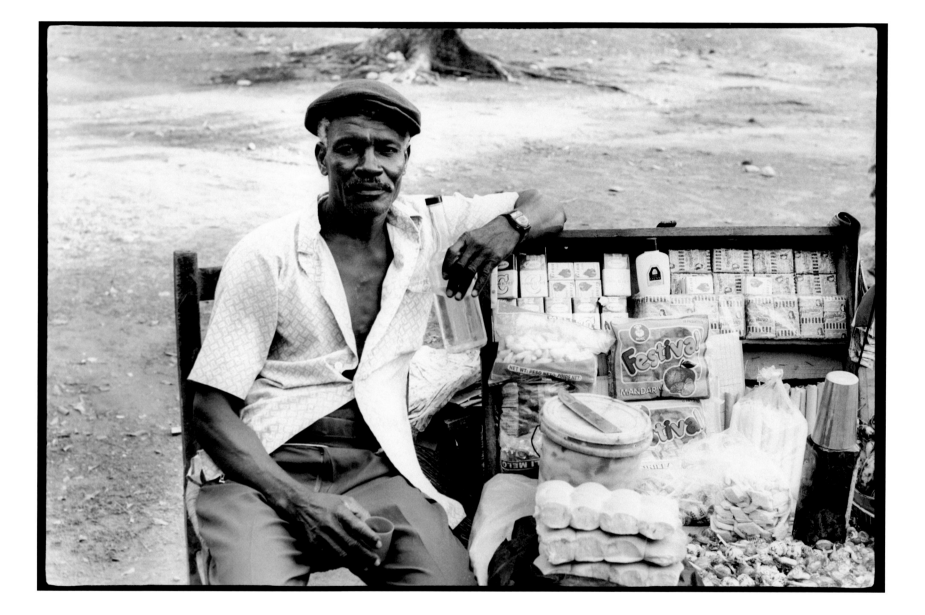

JÉ FON KRIYÉ DAVANS.

The deep eye sockets cry first.

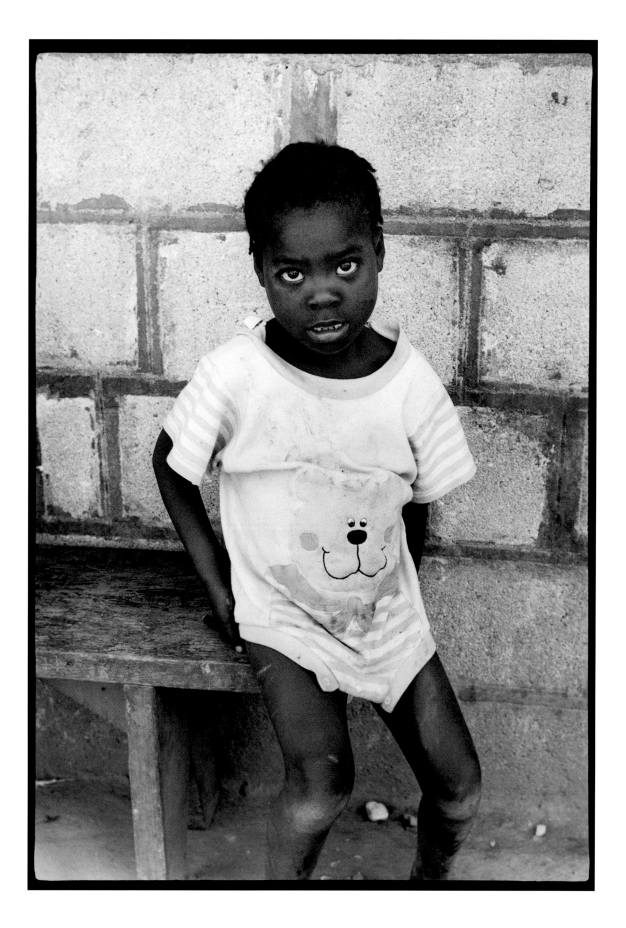

MALÈ PA GIN KLAKSONN.

Misfortune has no horn.

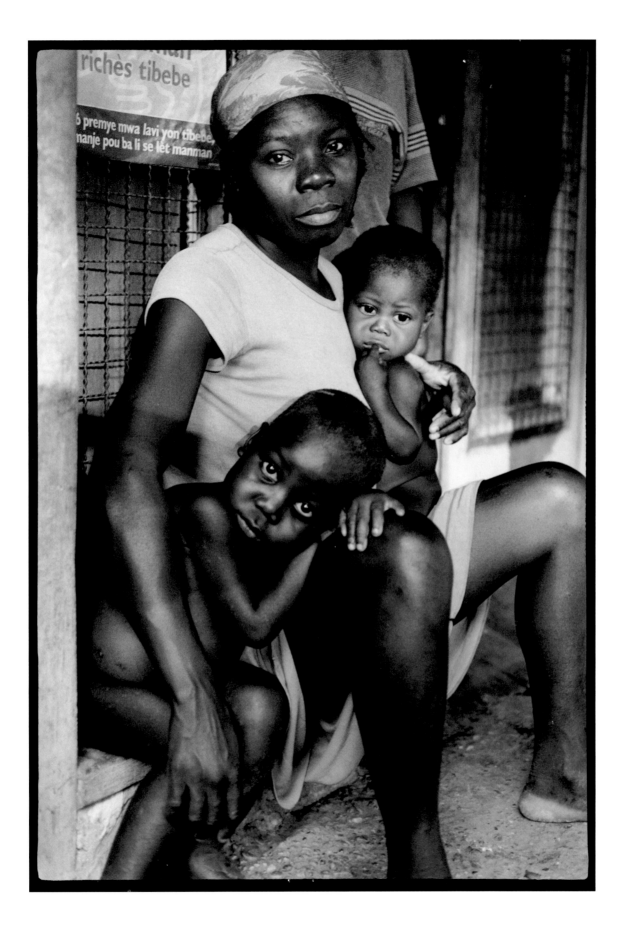

BON DIÉ KONNIN POUKI SA LI BAY
CHIN MALING DÈYÈ TÈT.

God knows why he gives a dog sores on his head.

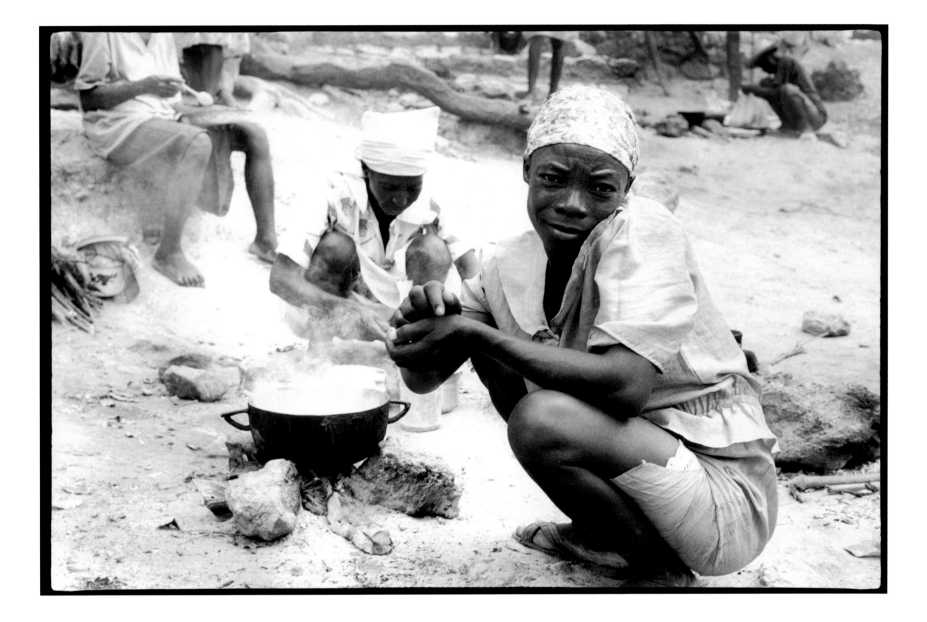

KOTÉ YAP PLIMIN KÒDINN, POUL PA RI.

Where they pluck turkey feathers, chicken shouldn't laugh.

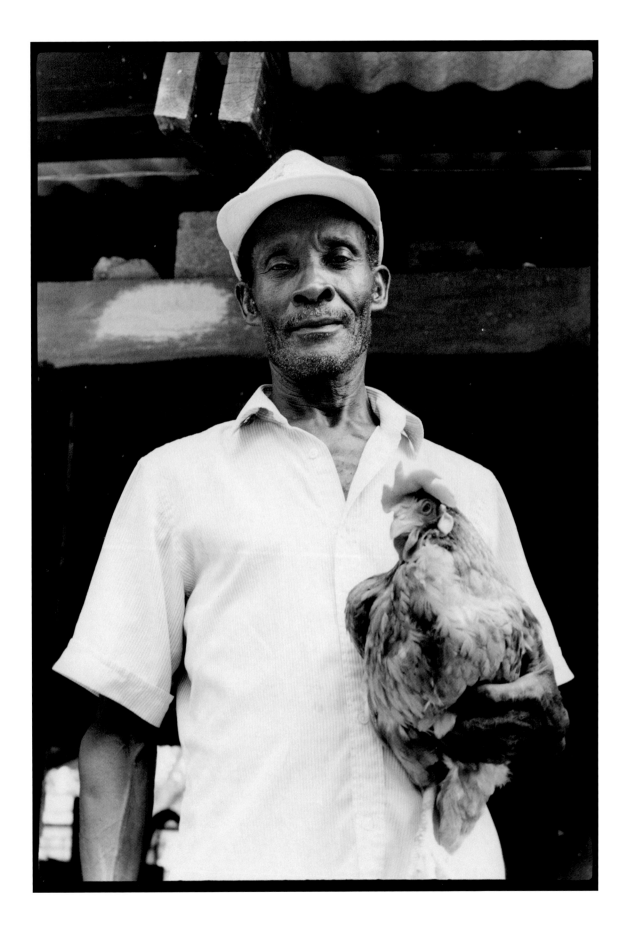

OU VLÉ TOUT, OU PÈDU TOUT.

You want all; you lose all.

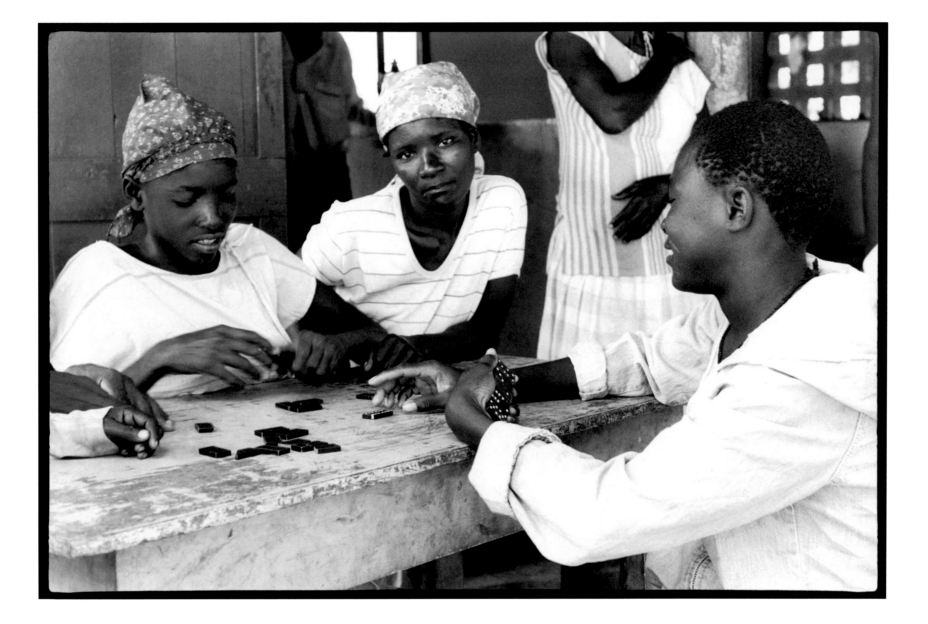

JOU VA, JOU VYIN.

Day goes, day comes.

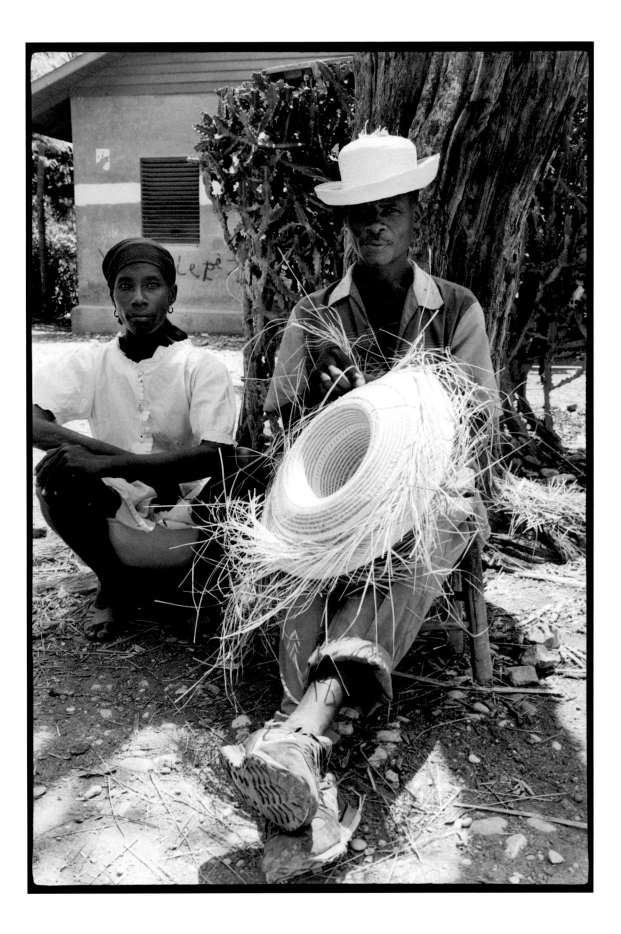

OU BAT TANBOU ÉPI OU DANSÉ ANKÒ.

You beat drum and you dance again.

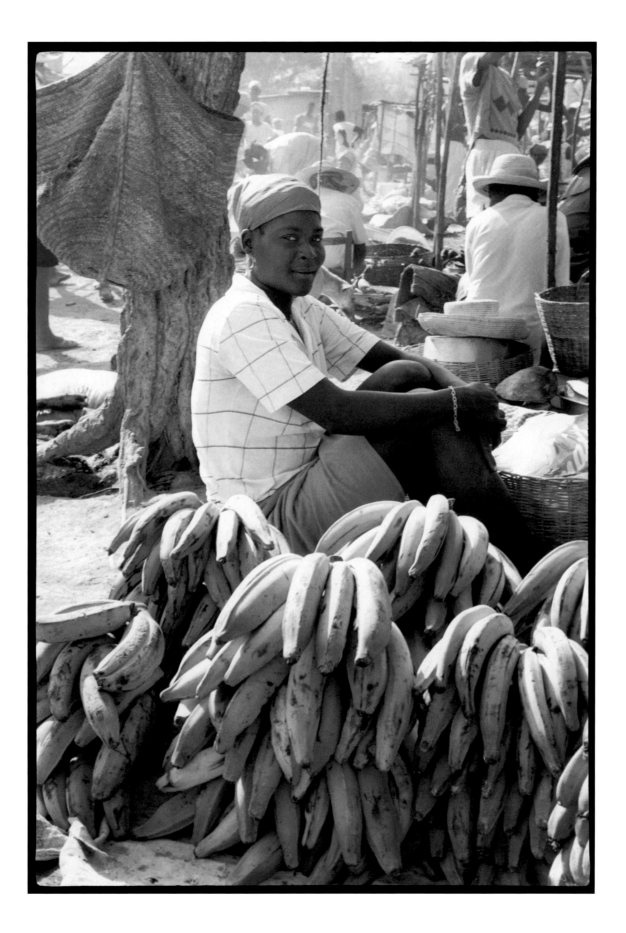

MÉRITÉ PA MANDÉ.

To deserve is not to ask.

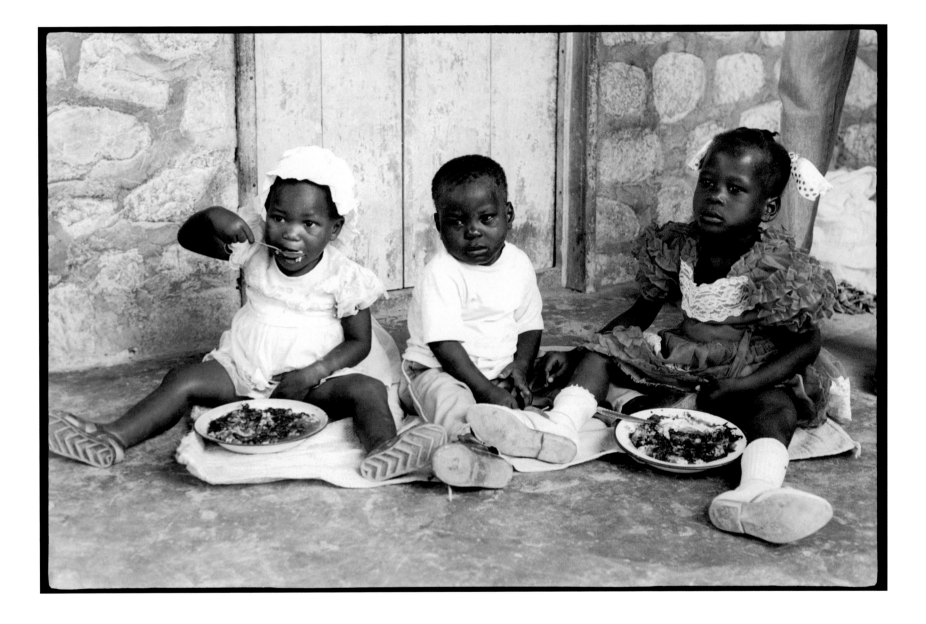

MALADI RANJÉ DOKTÈ.

Sickness favors doctors.

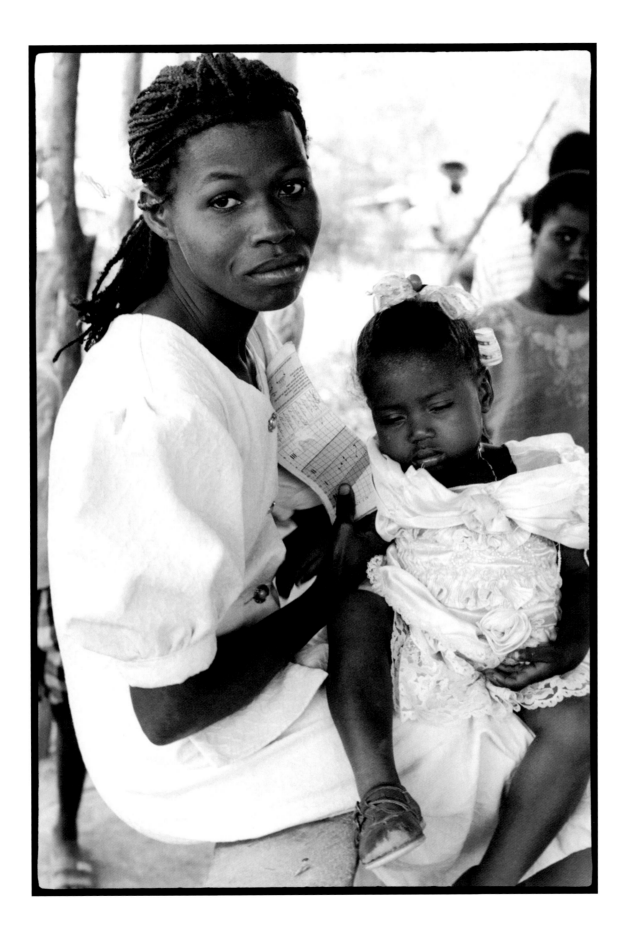

Sɪ sé Bon Dɪé ᴋɪ voyé, Lɪ ᴘéyé ꜰʀè ou.

If it's God who sends, He pays the freight.

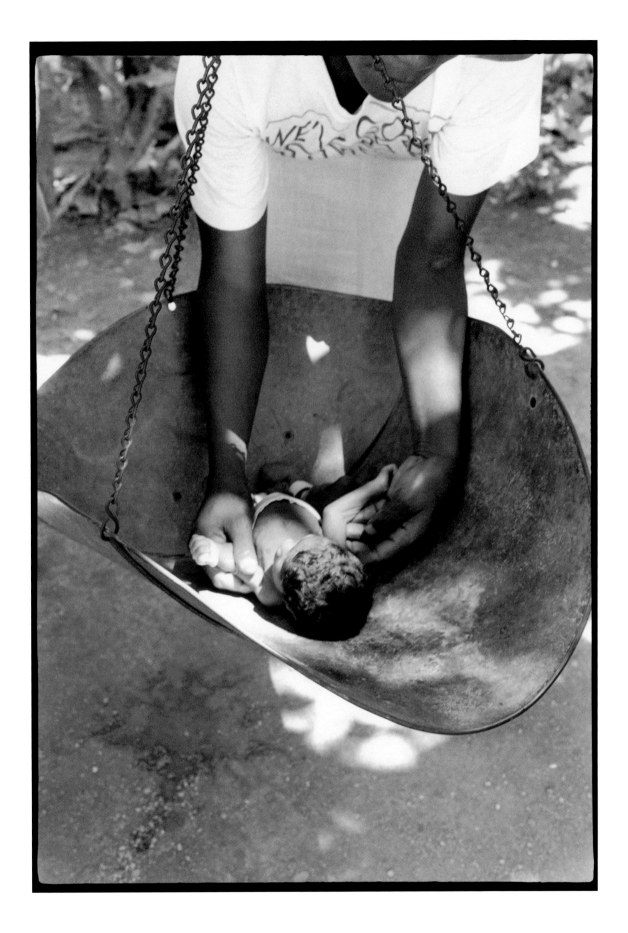

KOTÉ-K GIN BOUYON GIN SOUTNI TÈT.

Where there's broth there's holding up the head.

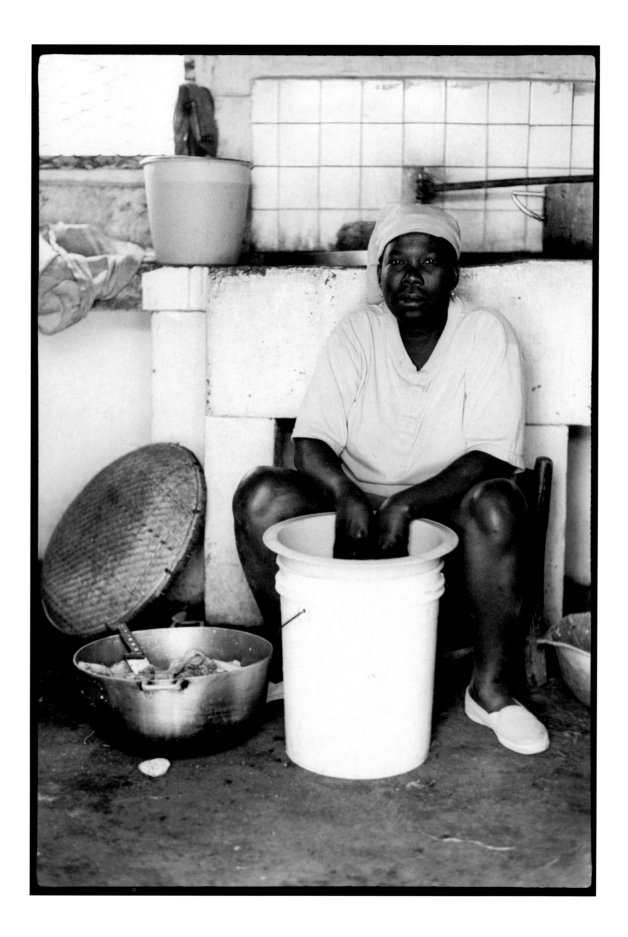

TI PIL, TI PIL FÈ CHAJ.

Little pile, little pile makes a load.

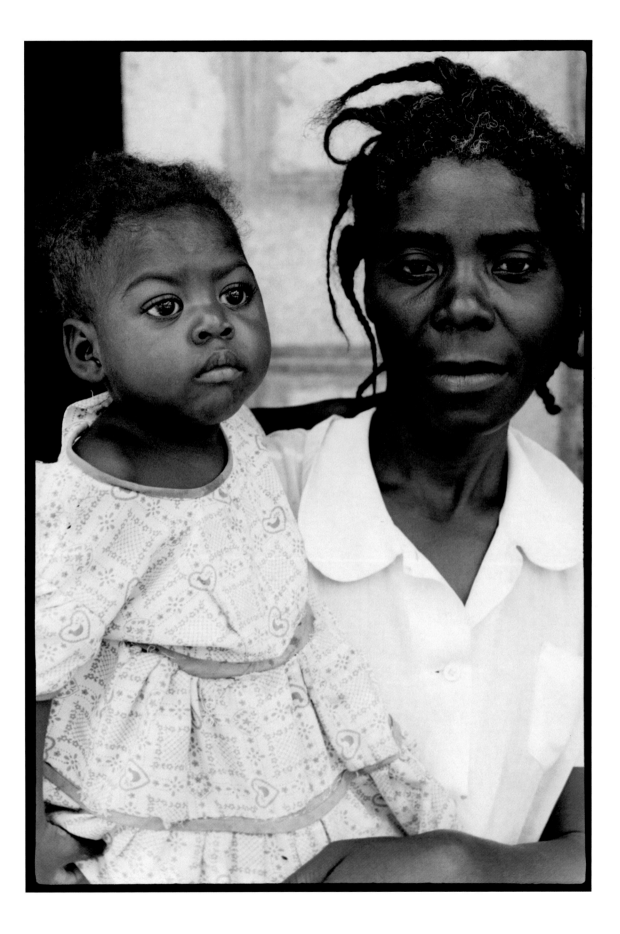

DÉGAJÉ PA PÉCHÉ.

To get along ain't a sin.

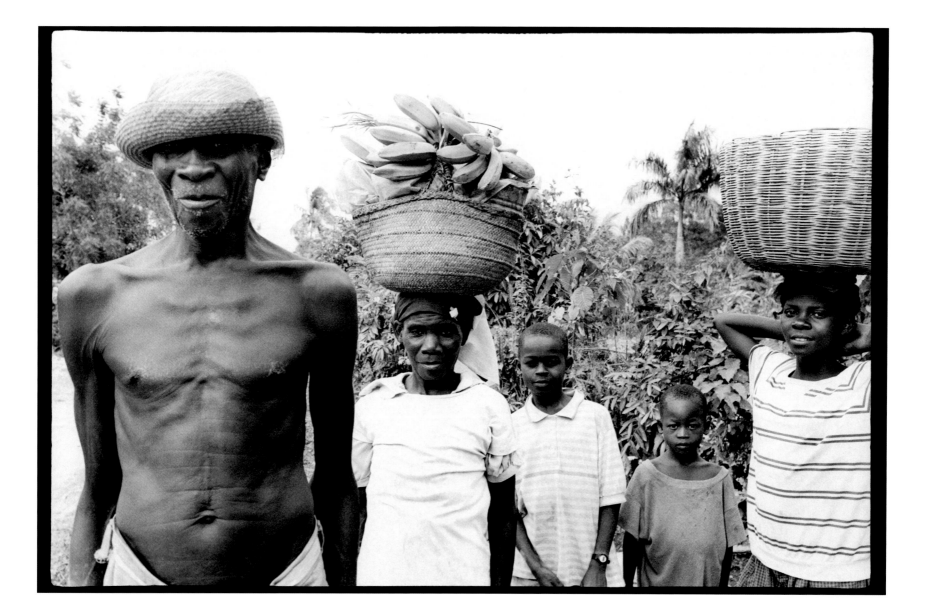

KRÉÒL PALÉ, KRÉÒL KONPRANN.

Créole talks, créole understands.

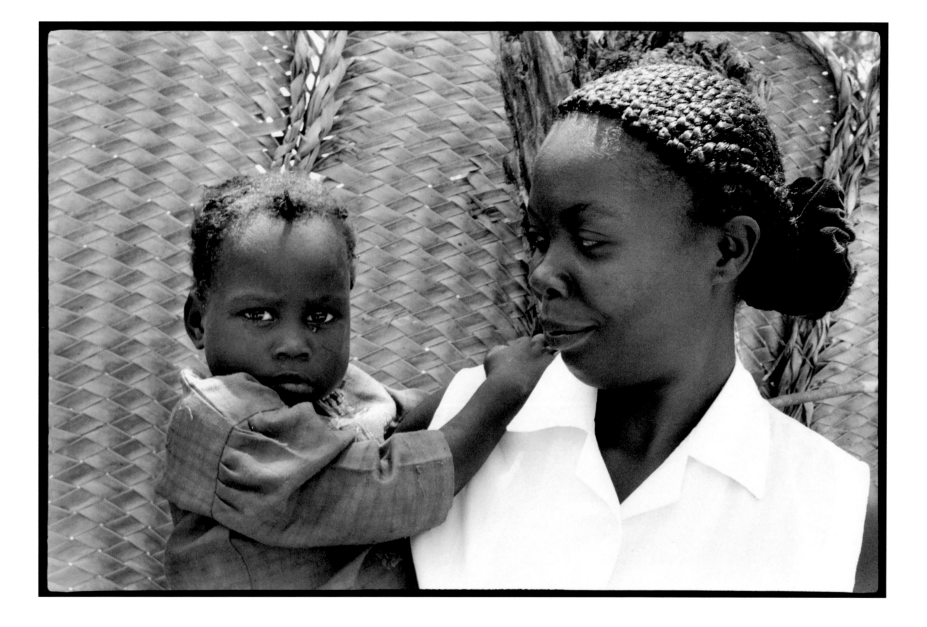

TOUT KOUKOUJ KLÉRÉ POU JÉ YO.

All lightning bugs shine for their own eyes.

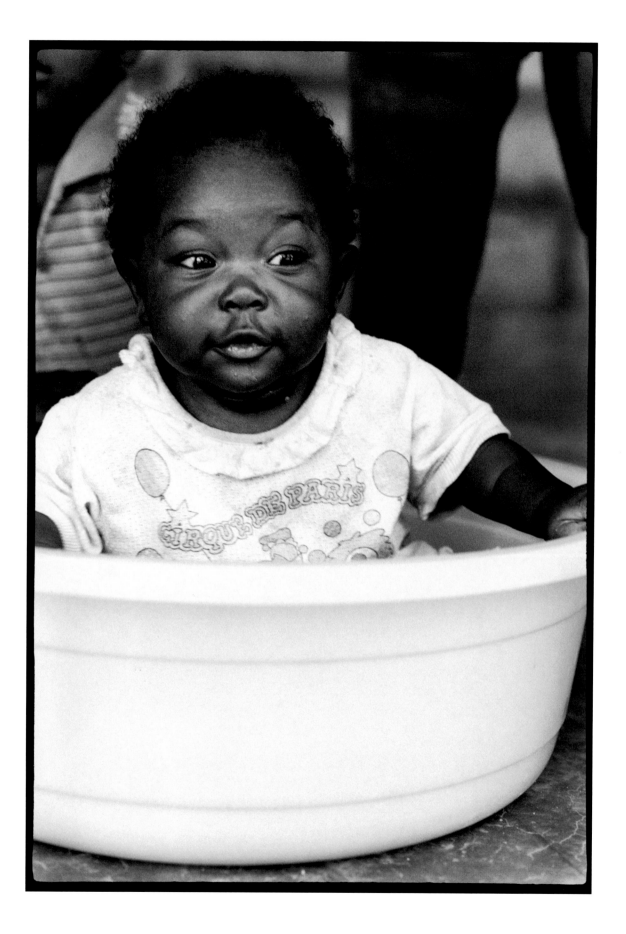

DÒMI SÉ TI FRÈ LANMÒ.

Sleeping is little brother to death.

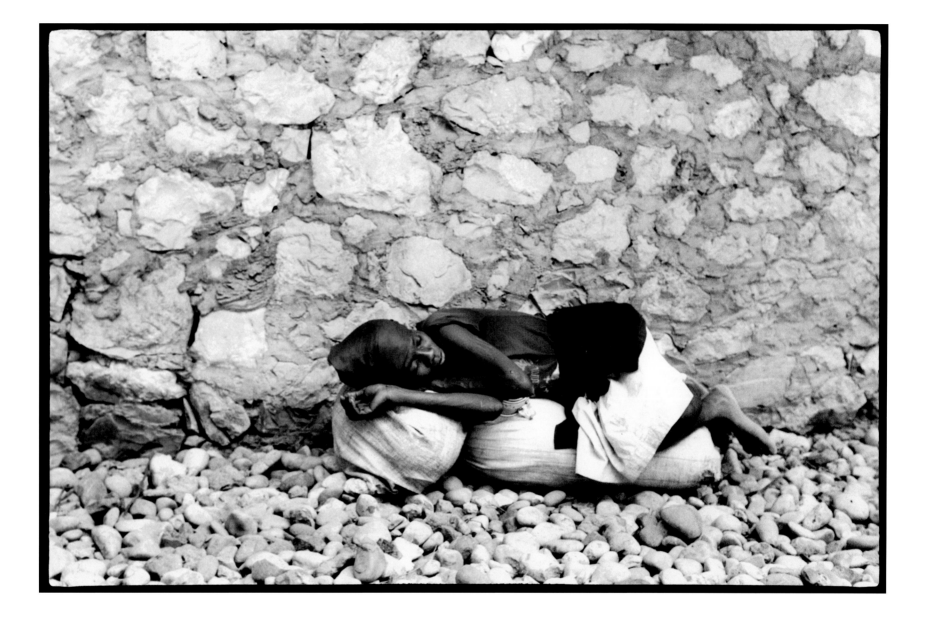

BON PA GASPIYÉ.

A good thing is not wasted.

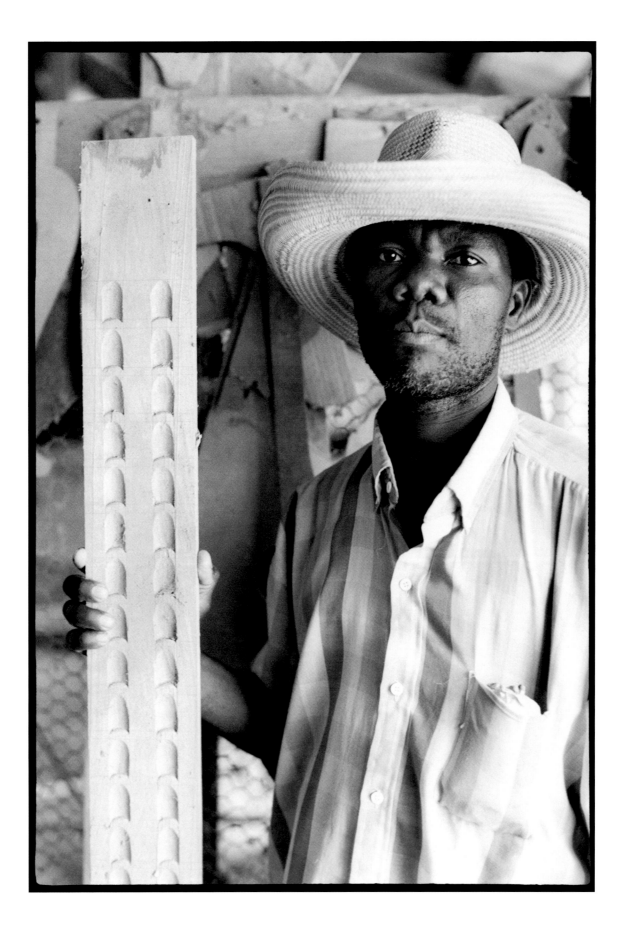

TAN ALÉ-L PA TOUNIN.

Time past doesn't return.

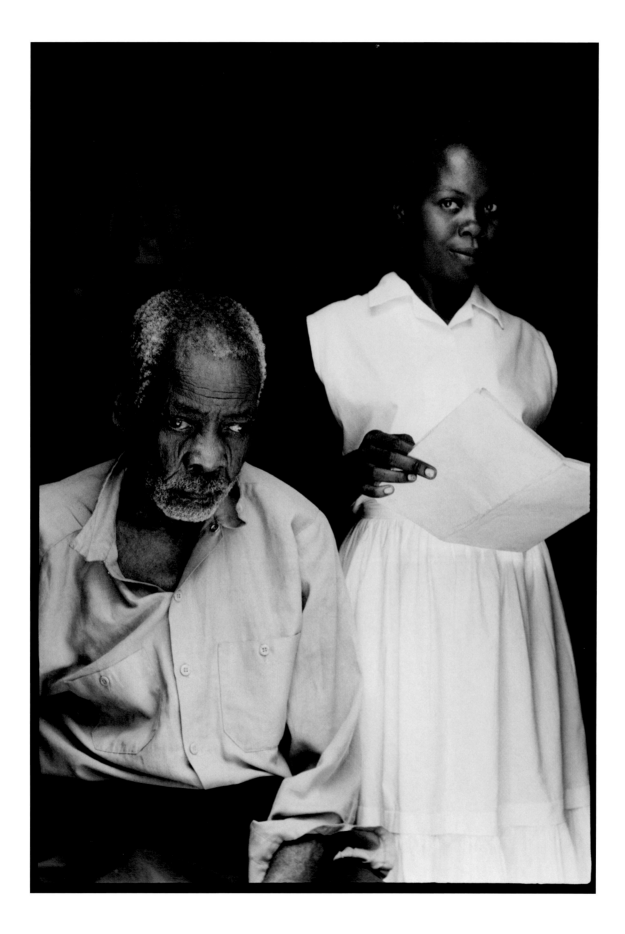

PITIT SÉ RICHÈS PÒV MALÉRÉ.

Children are riches for poor misfortunates.

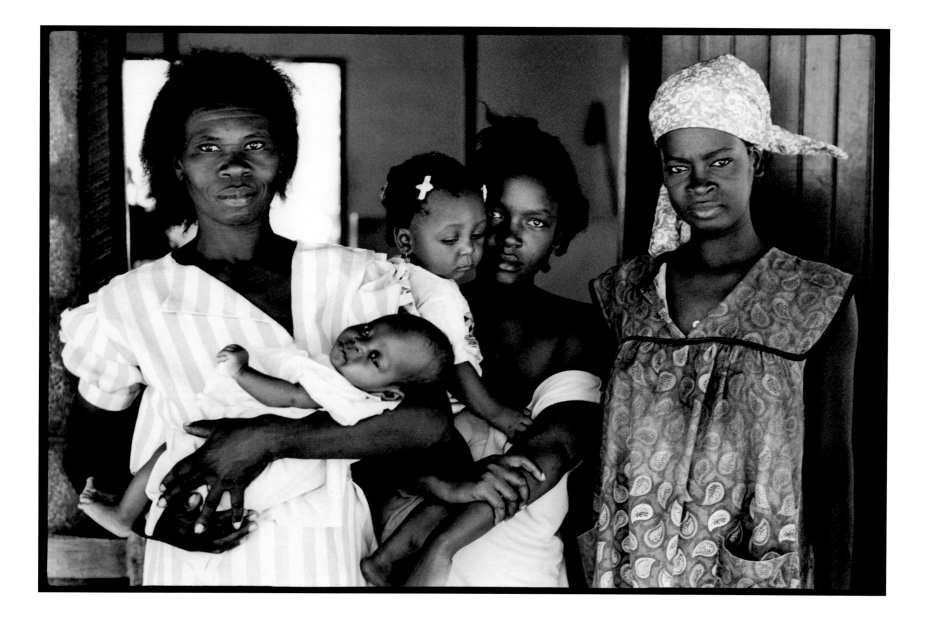

JÉ PA GIN BÒDAY.

The eye has no boundary.

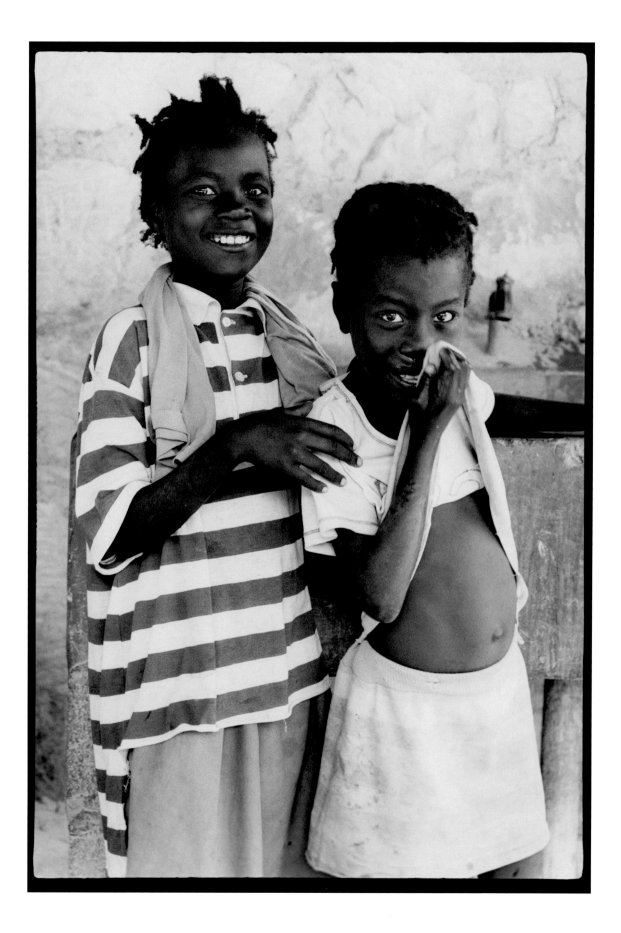

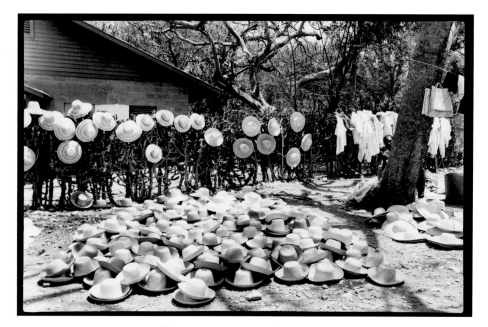

RAD PA JANM FÈ MOUN.
Clothes never make people.

THOUGH HAITI IS DENSELY POPULATED AND ONE OF THE POOREST OF COUNTRIES,
HER PEOPLE SURVIVE, WHEN THEY CAN, WITH LOVE AND DIGNITY. AND THEY DIE.
AT DESCHAPELLES, IN THE REMOTE ARTIBONITE VALLEY,
HÔPITAL ALBERT SCHWEITZER HAS ITSELF SURVIVED POLITICAL AND ECONOMIC CHAOS
AND SERVED THESE PEOPLE FOR FIFTY YEARS.

ANDREA BALDECK, LIKE MANY OTHERS FROM AROUND THE WORLD,
WORKED AS A PHYSICIAN AT THE HOSPITAL IN 1981, 1983, AND 1985.
IN 1996, SHE RETURNED AS A PHOTOGRAPHER.

Design and Production of this book were managed by
Veronica Miller & Associates
Haverford, Pennsylvania.
Tritone Seperations and Production supervision
were provided by Peter Philbin.
This book was printed by Oak Lane Printing, Inc.
Moorestown, New Jersey
in an edition of two thousand five hundred copies
and was bound by Hoster Bindery, inc.
Ivyland, Pennsylvania.
Published by the University of Pennsylvania Museum
of Archaeology and Anthropology
Philadelphia, Pennsylvania.